Kawaii
Coloring Book

A Huge Adult Coloring Book Containing 40 Cute Japanese Style Coloring Pages for Adults and Kids

Adult Coloring world

Copyright © 2015 Adult Coloring World

All rights reserved.

ISBN-13: 978-1519666413

ISBN-10: 1519666411

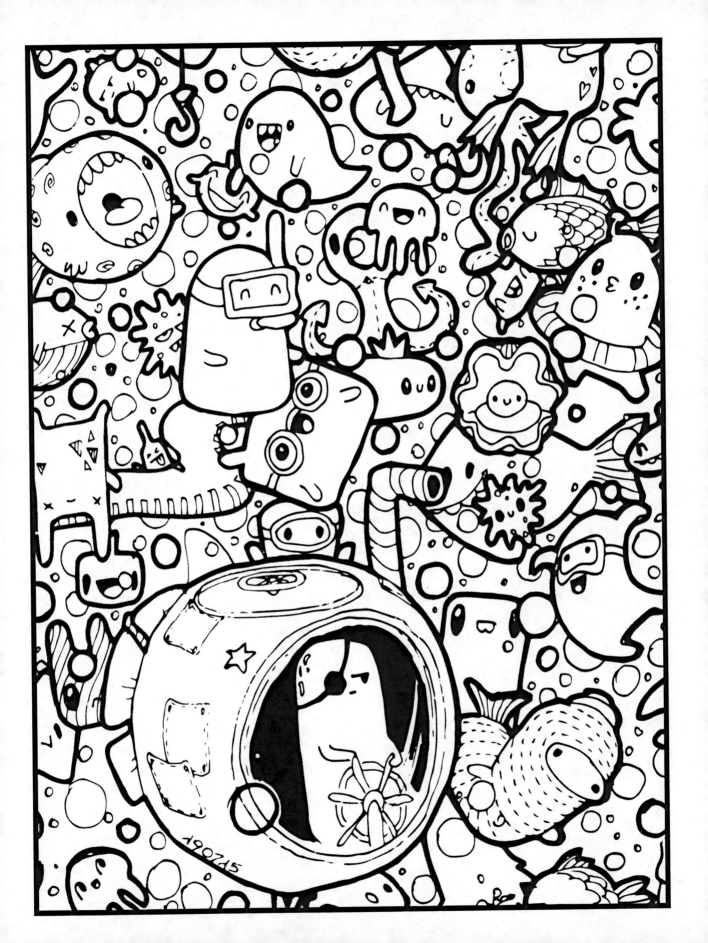

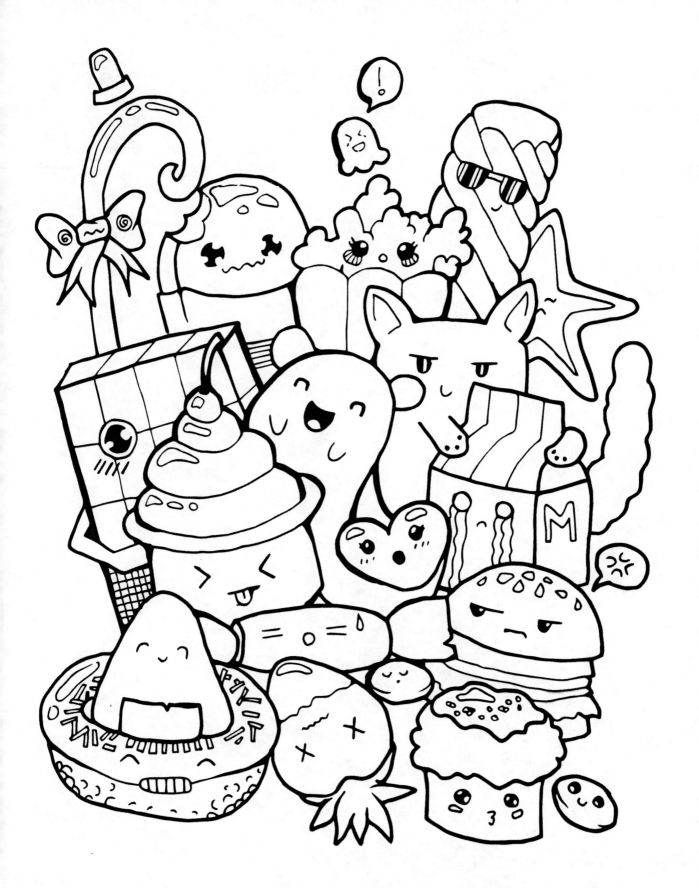

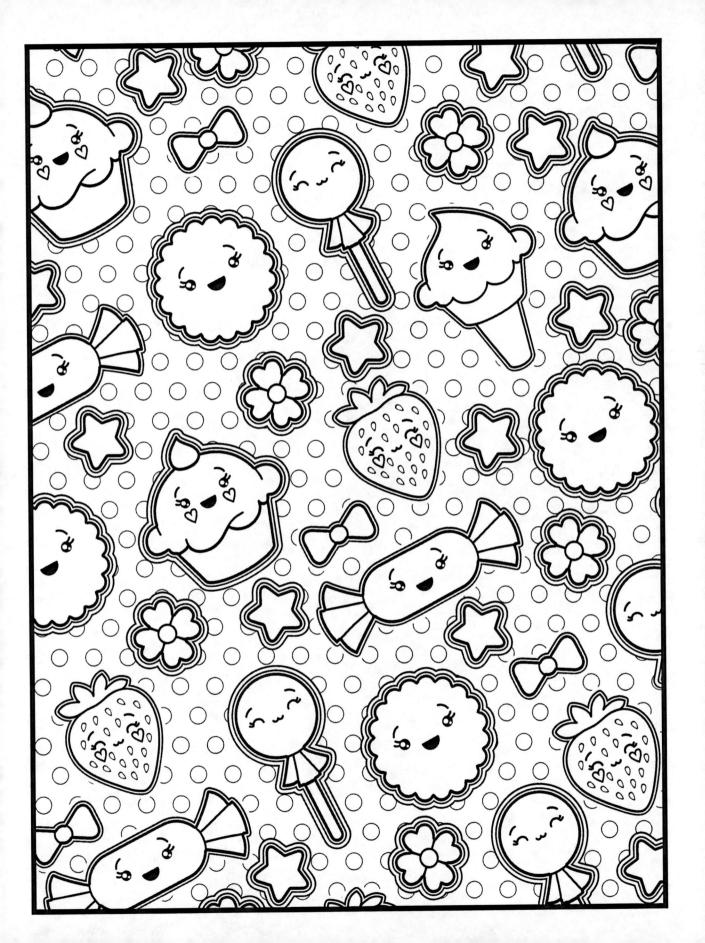

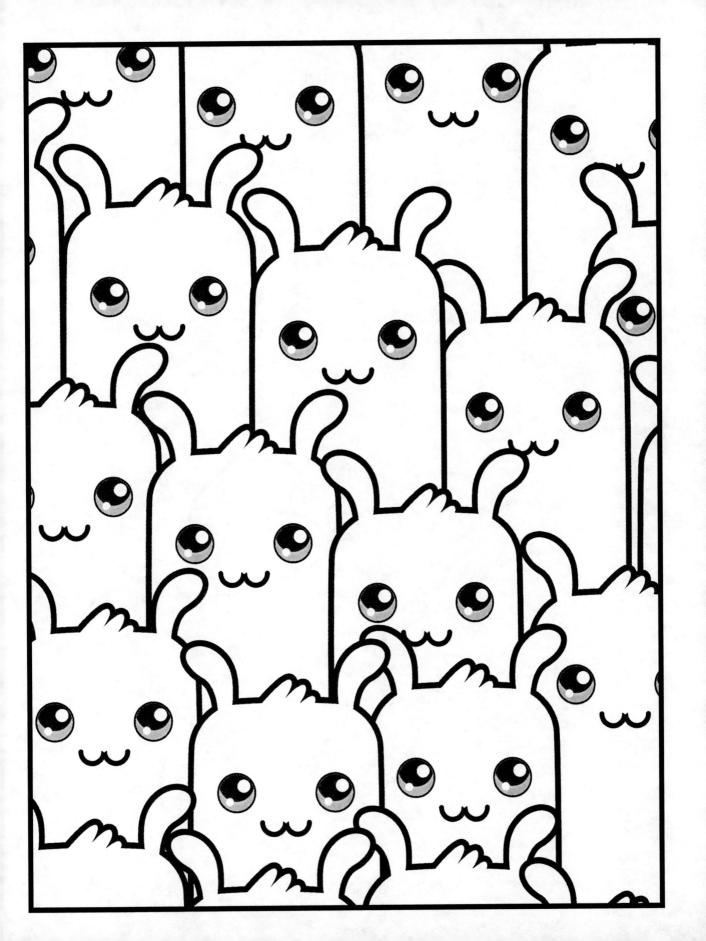

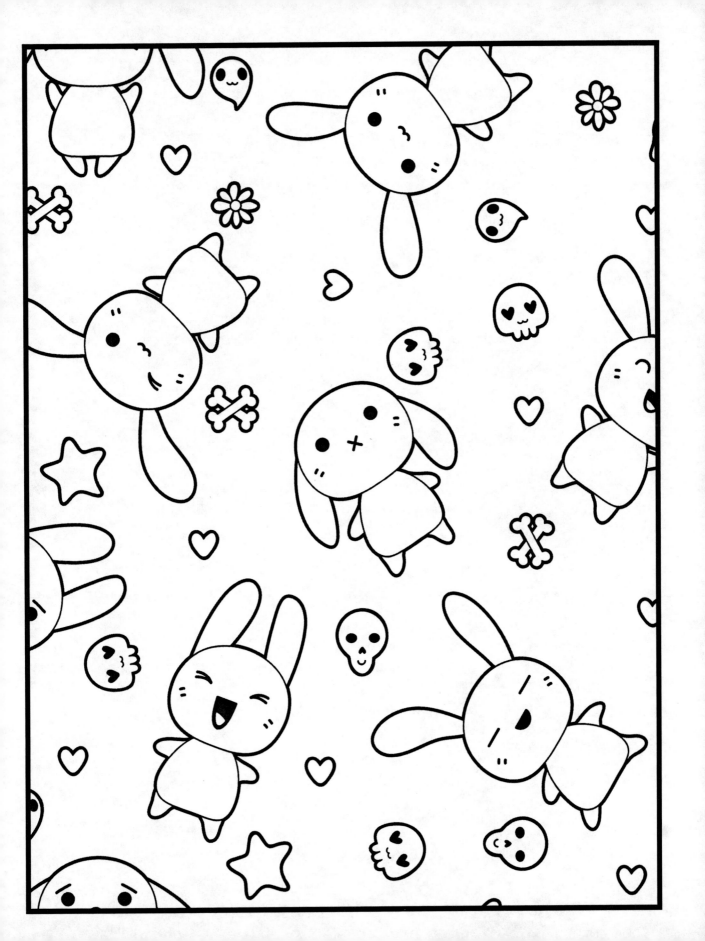

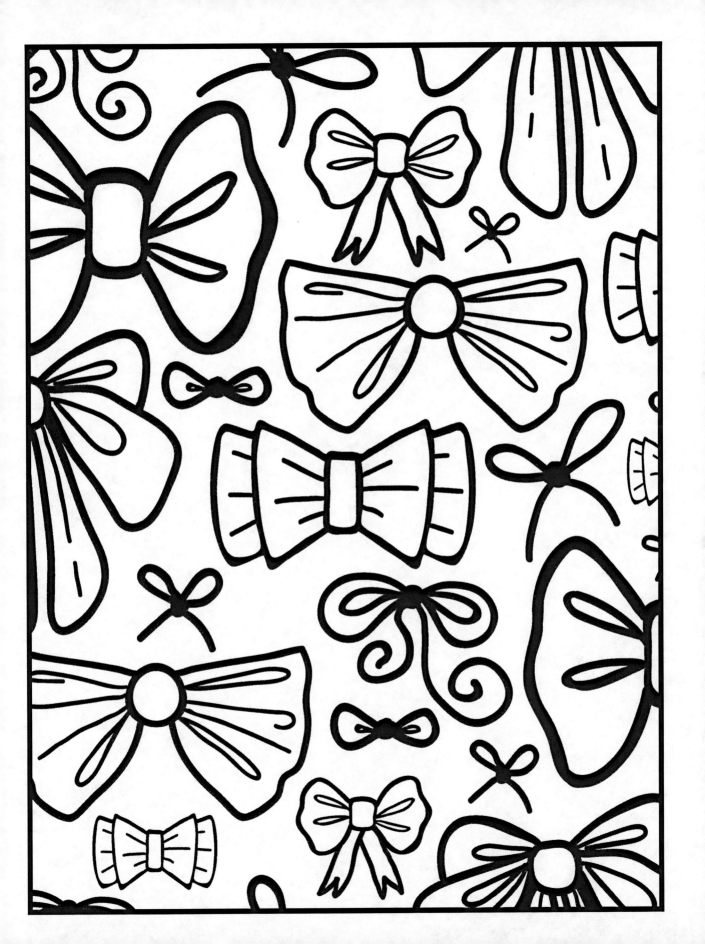

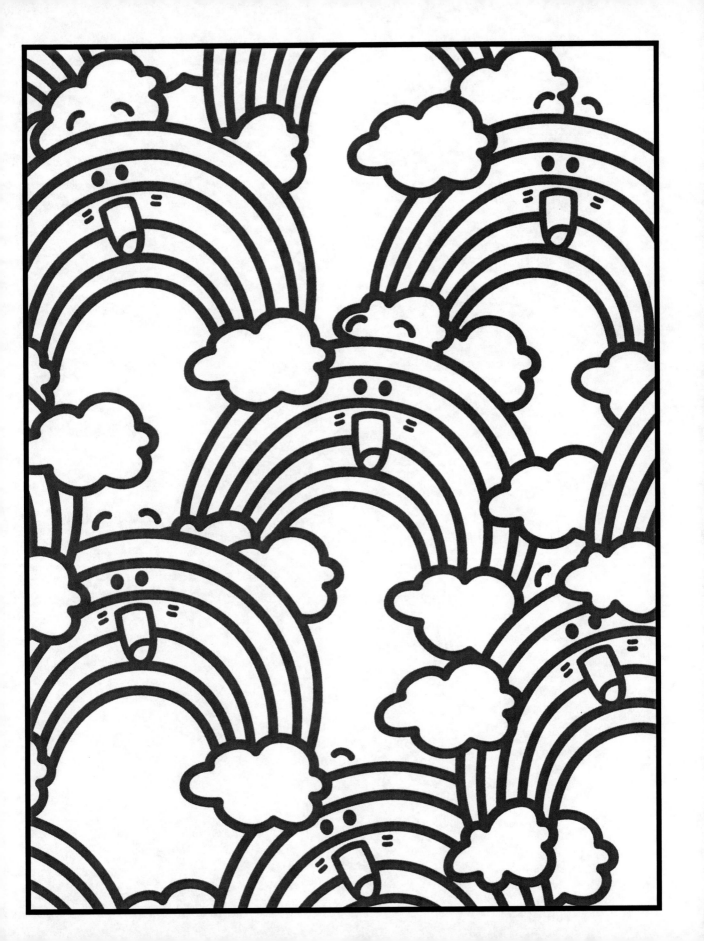

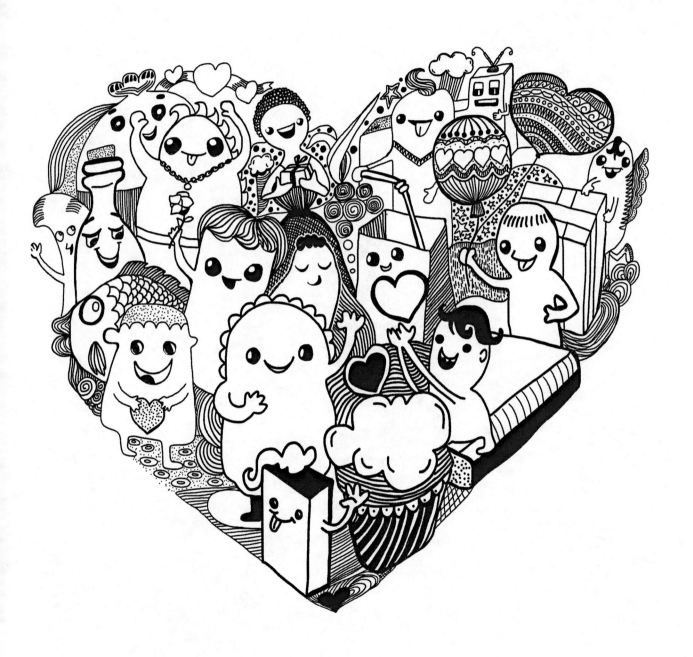

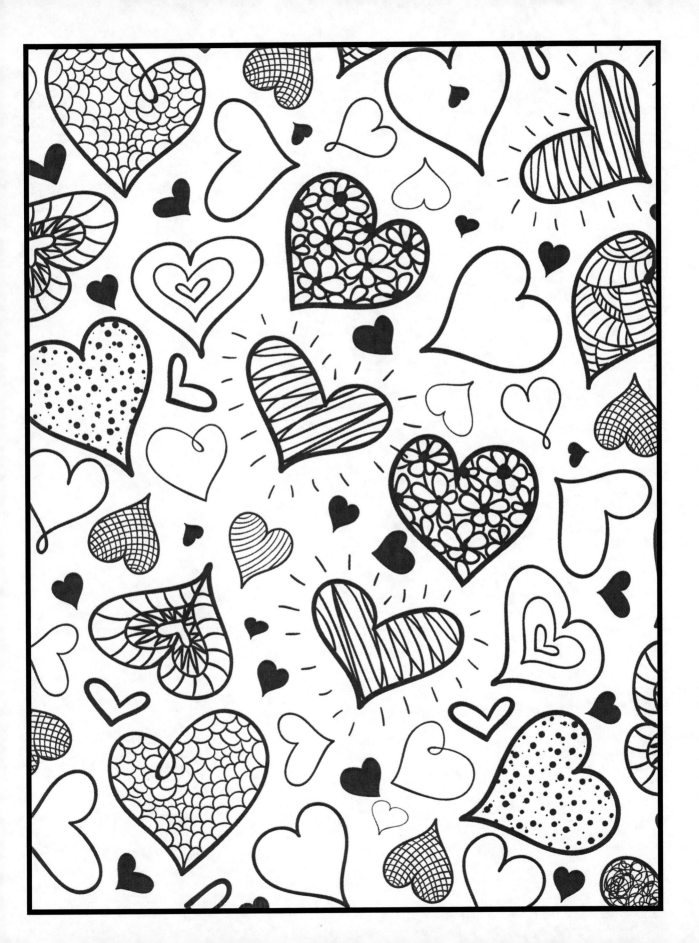

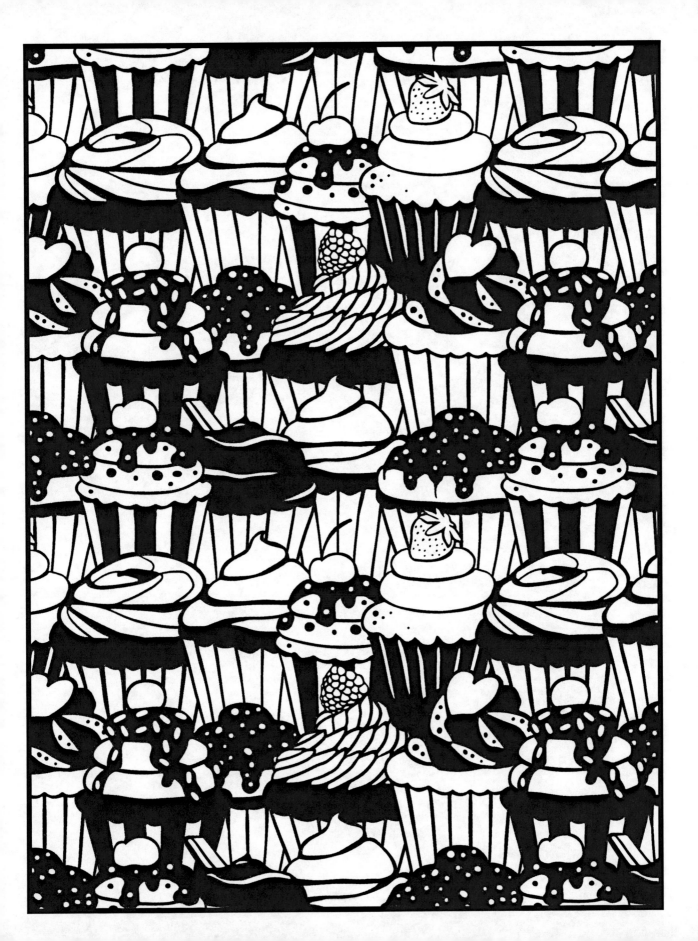

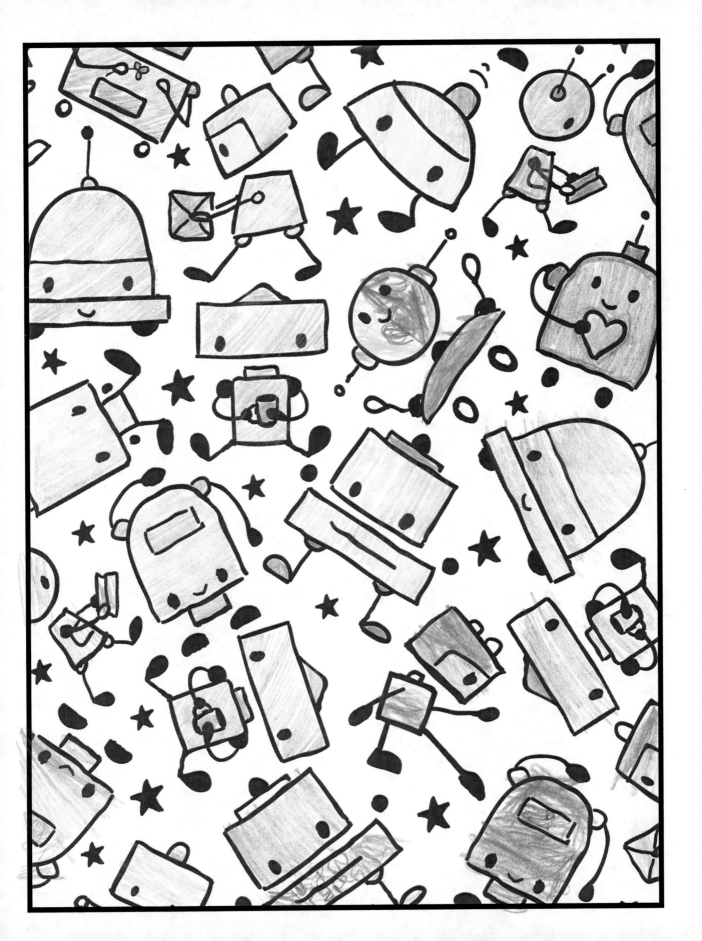

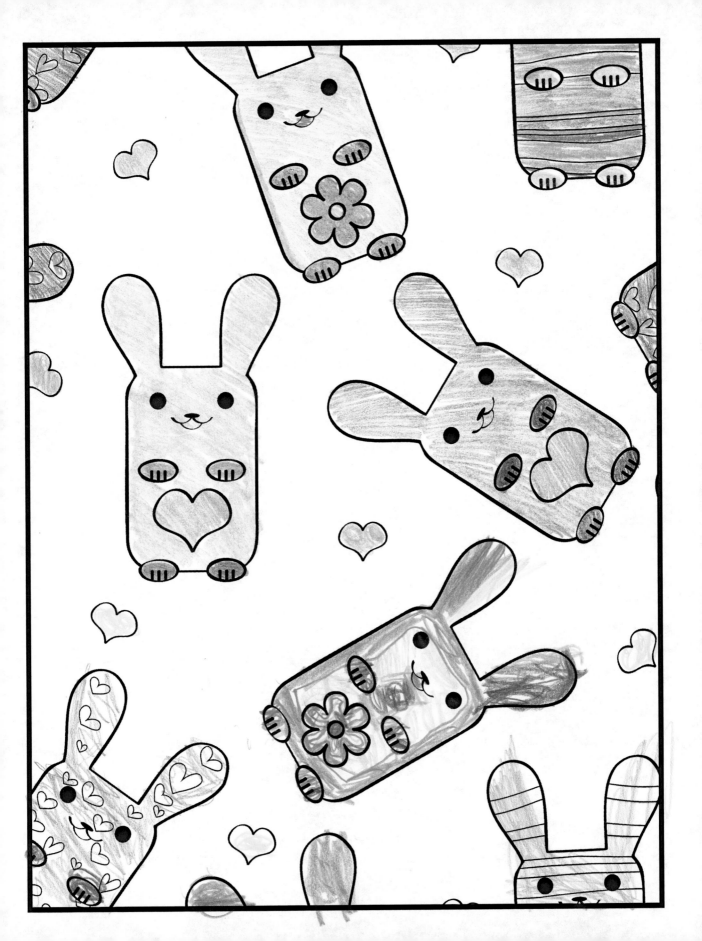

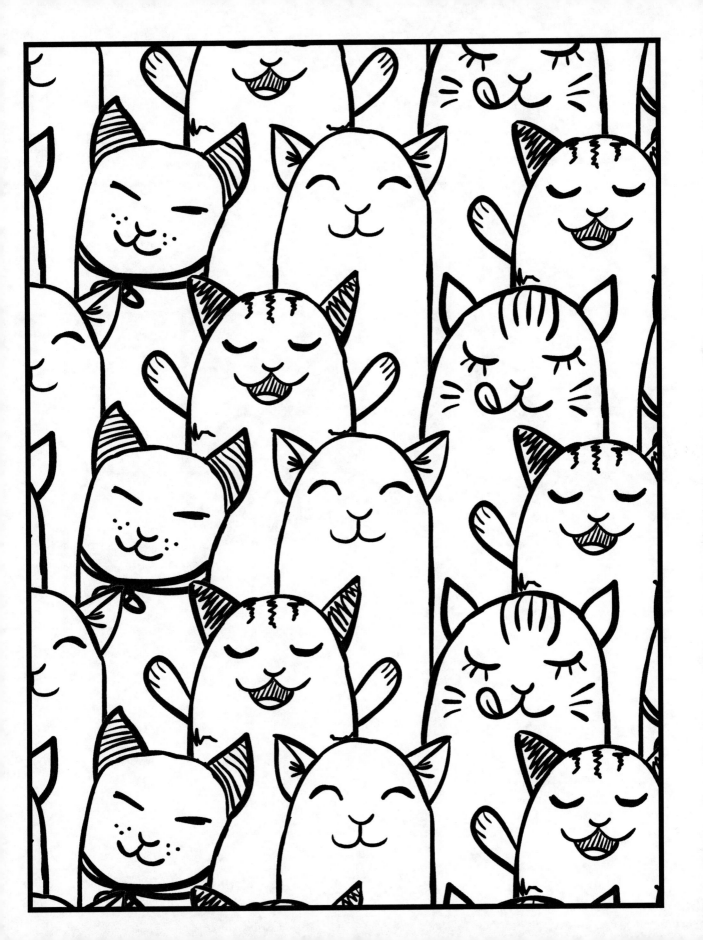

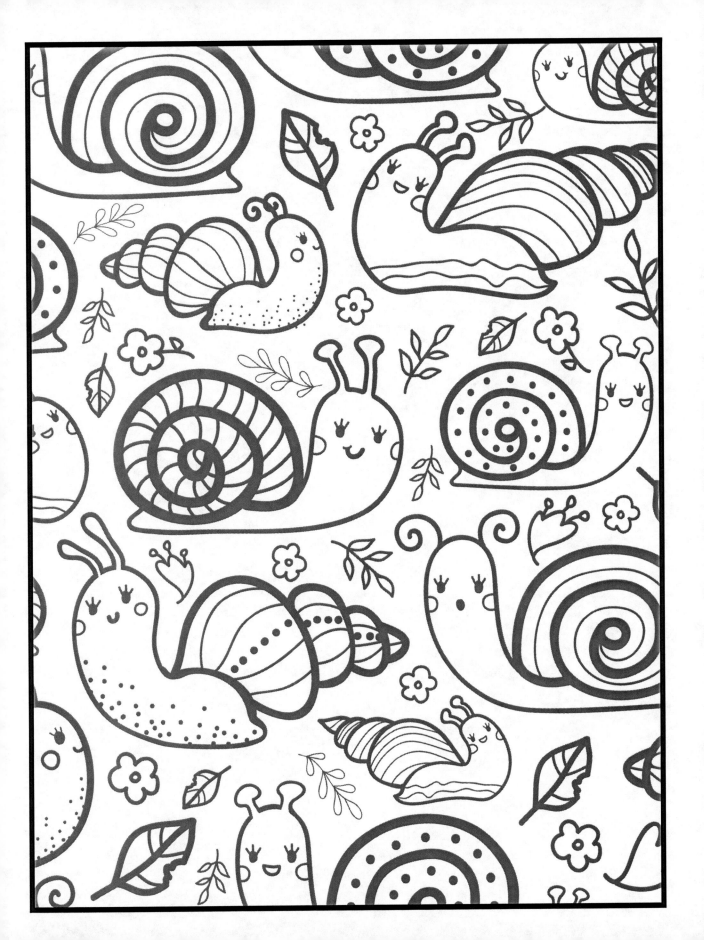

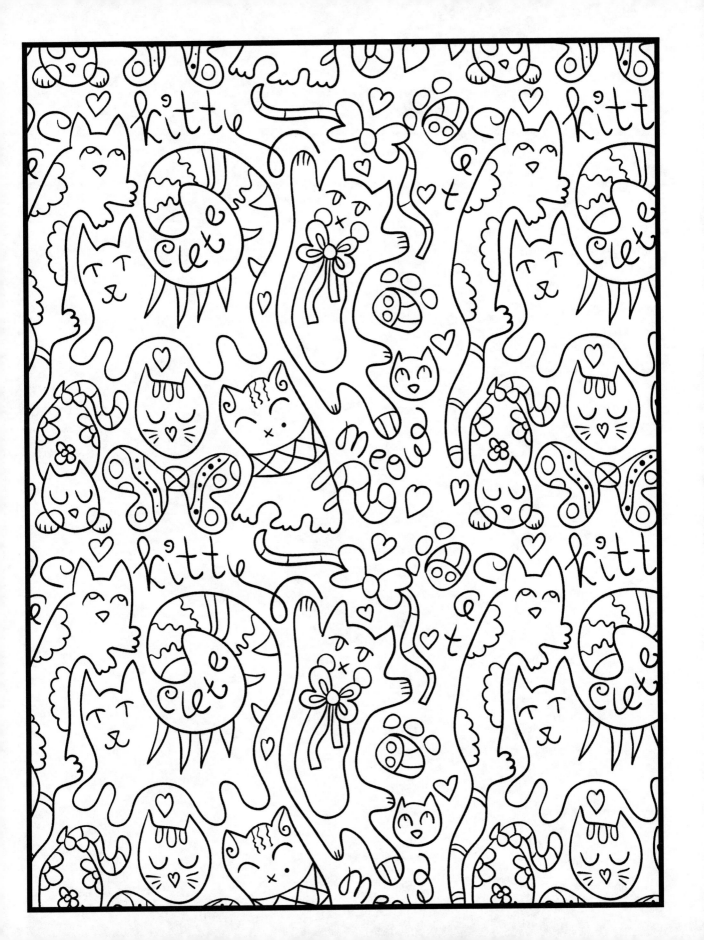

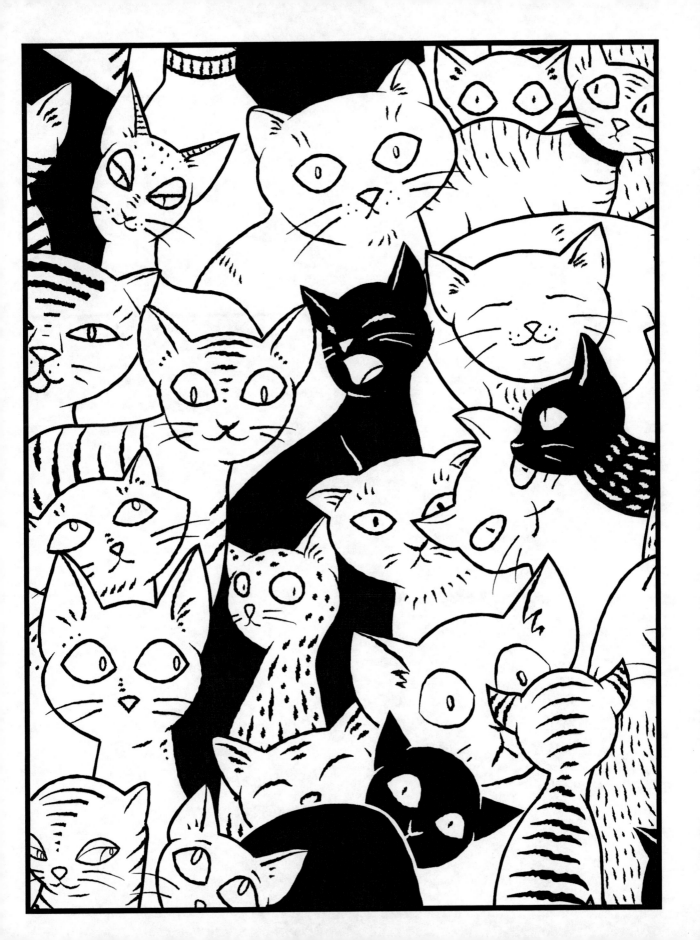

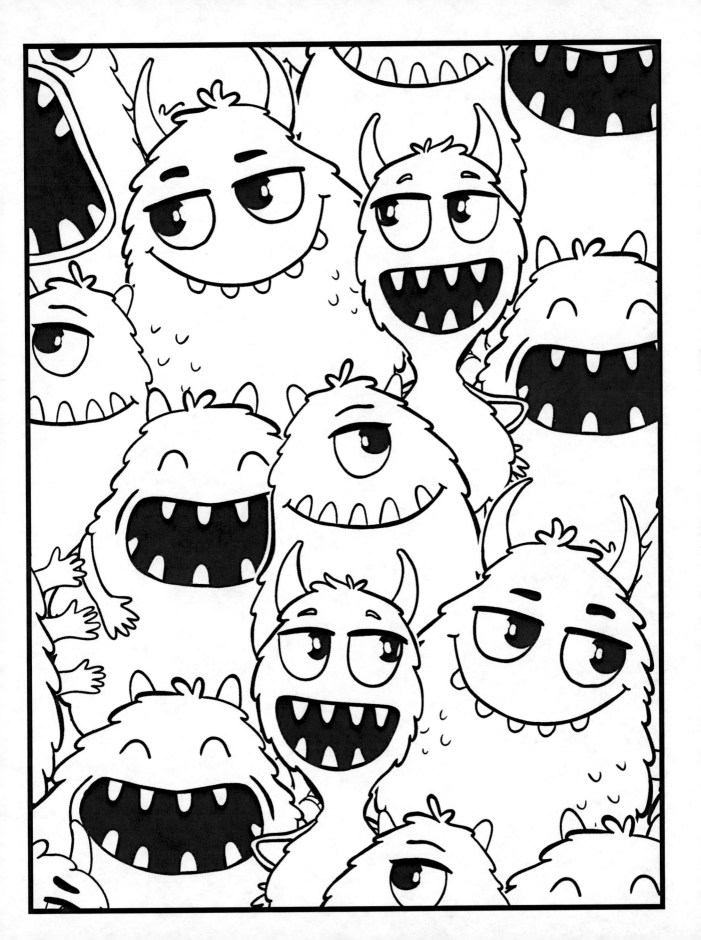

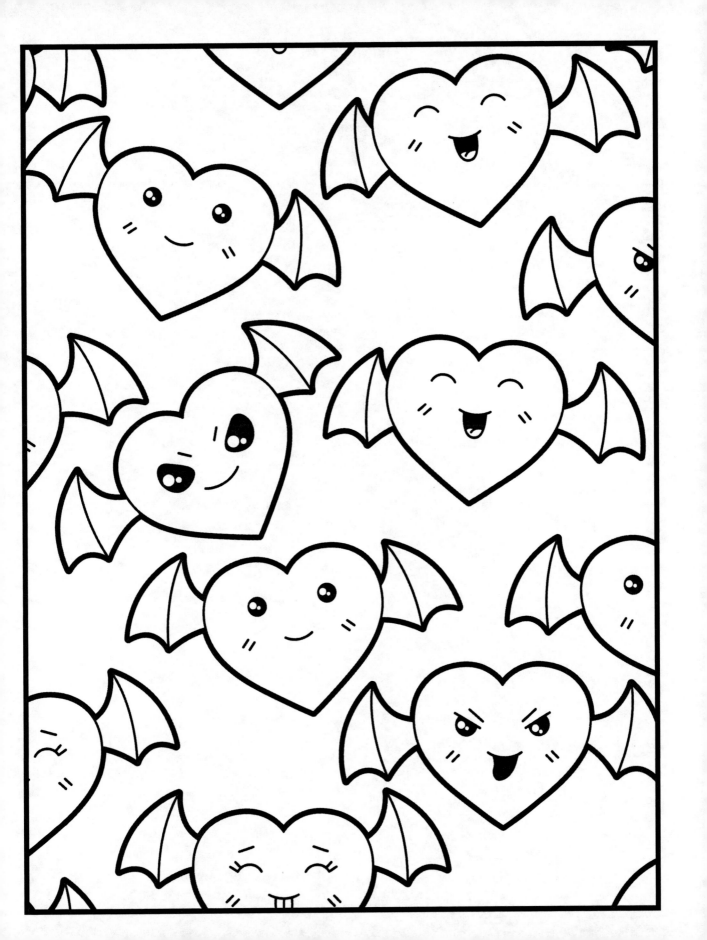

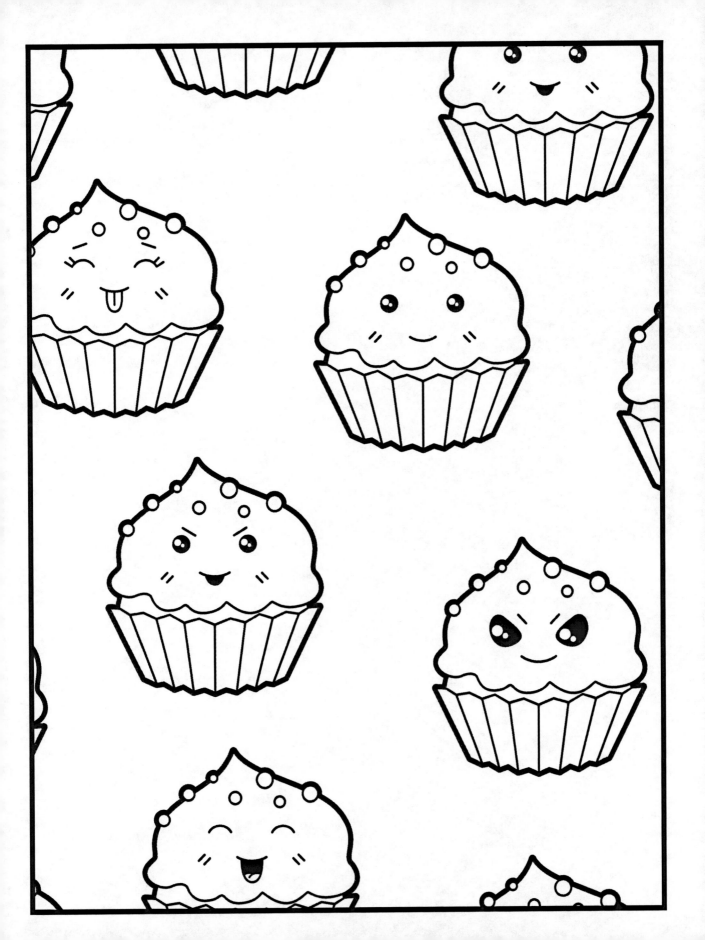

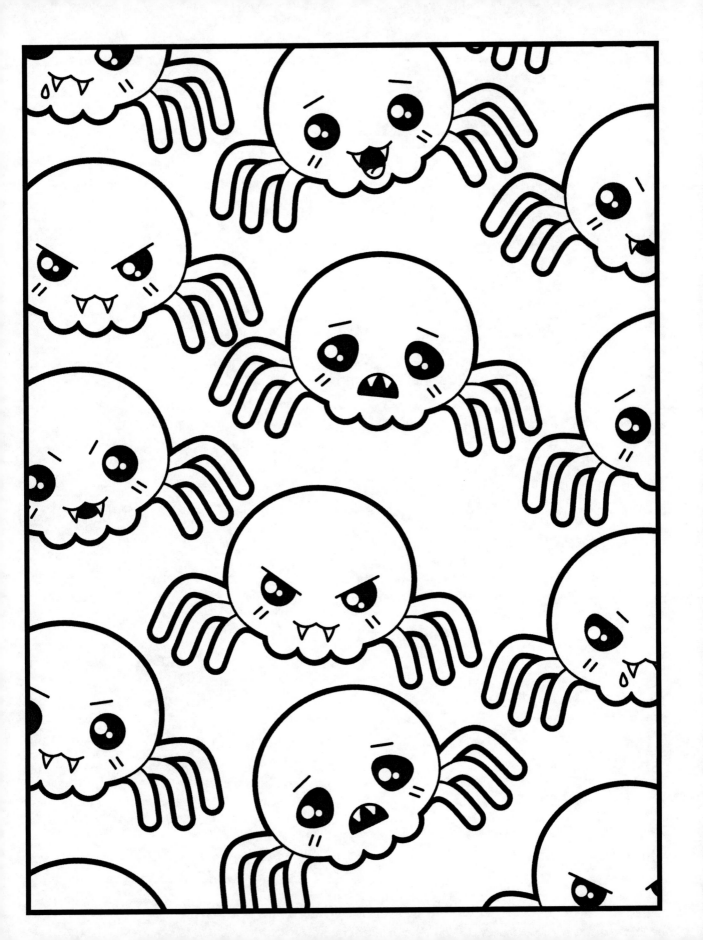

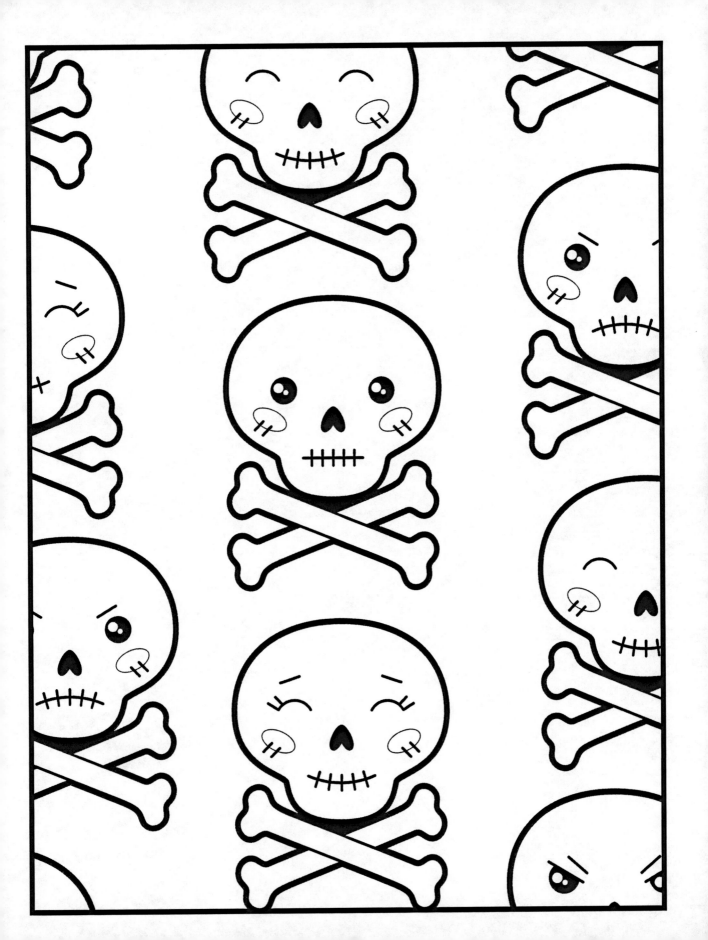

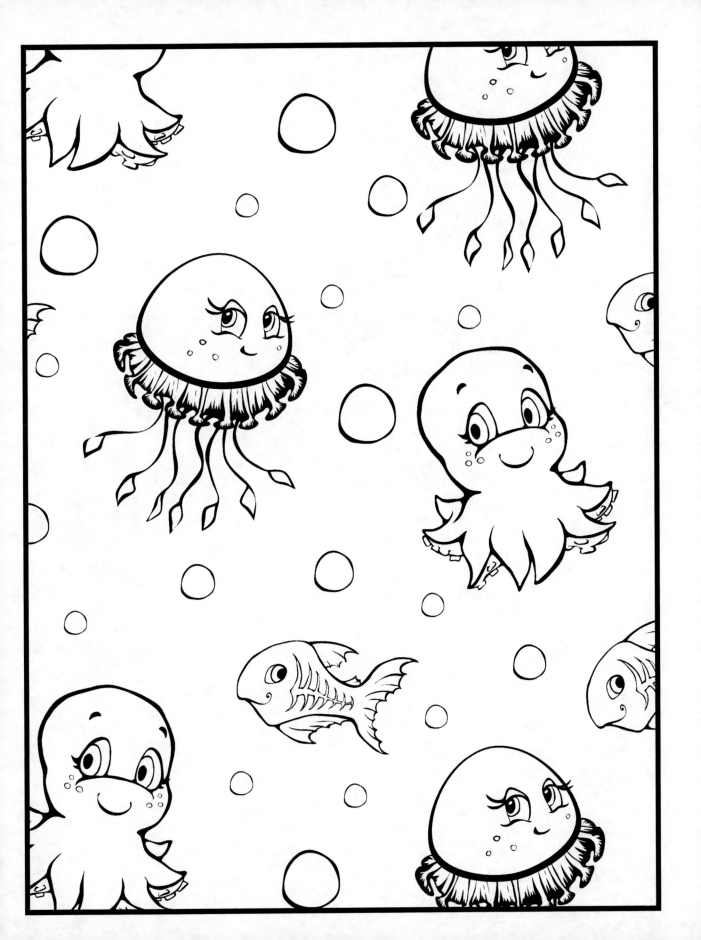

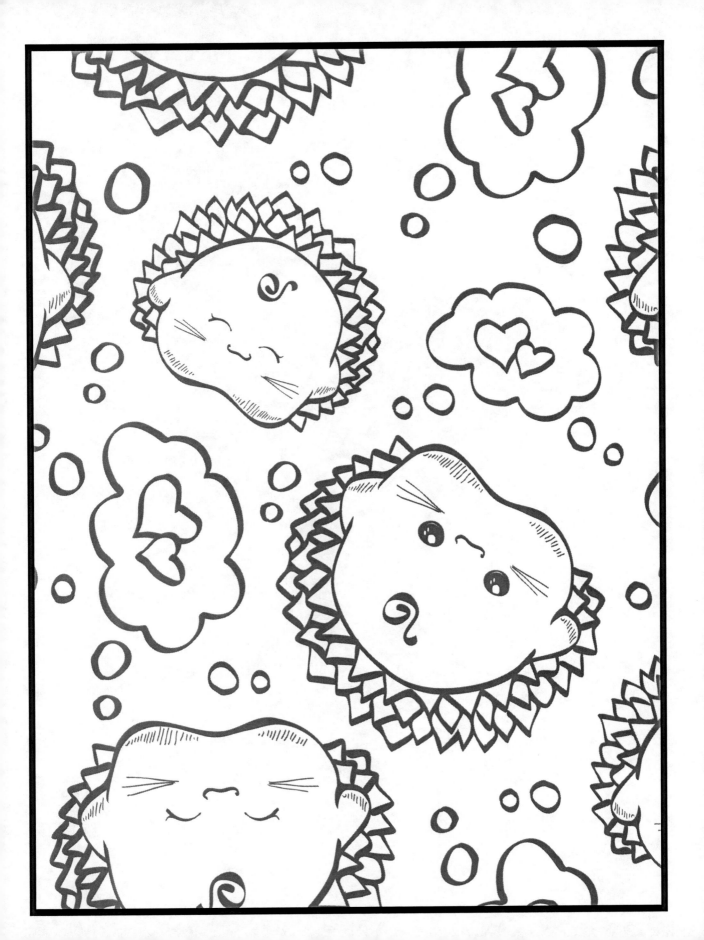

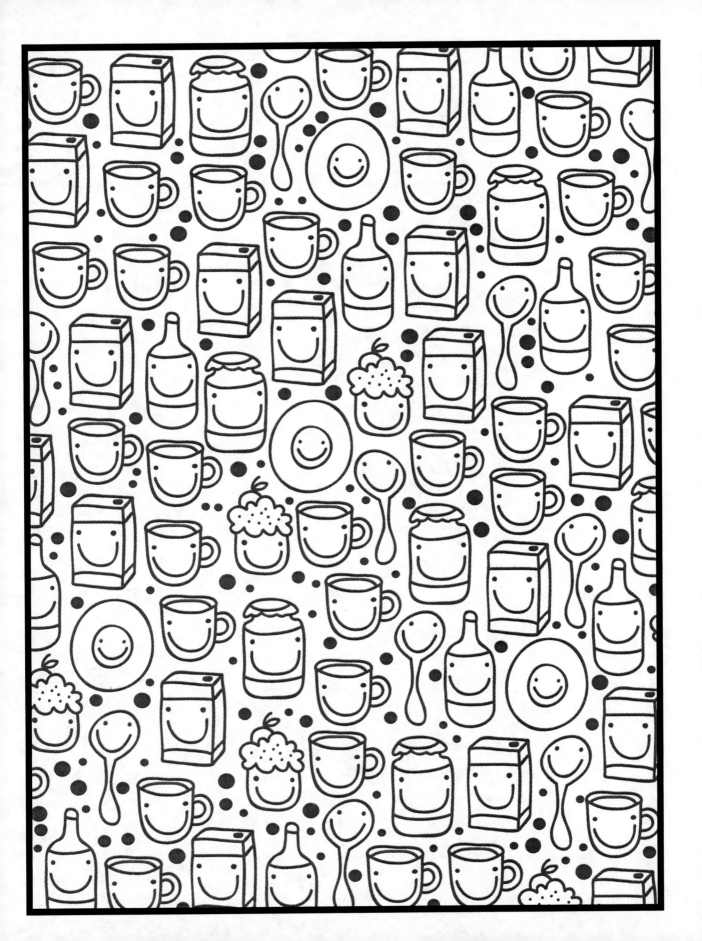

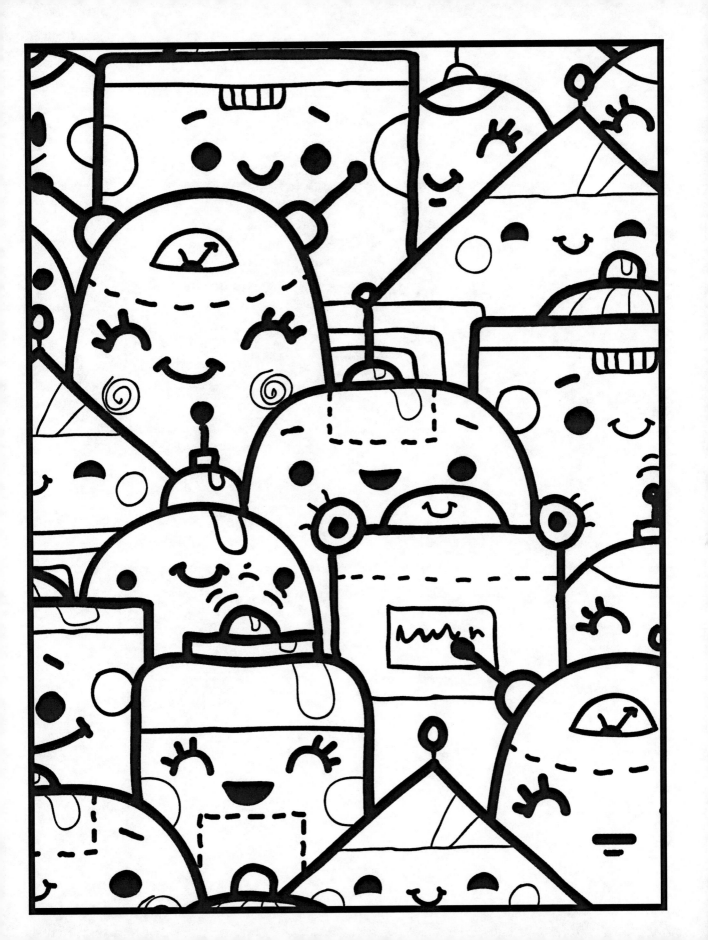

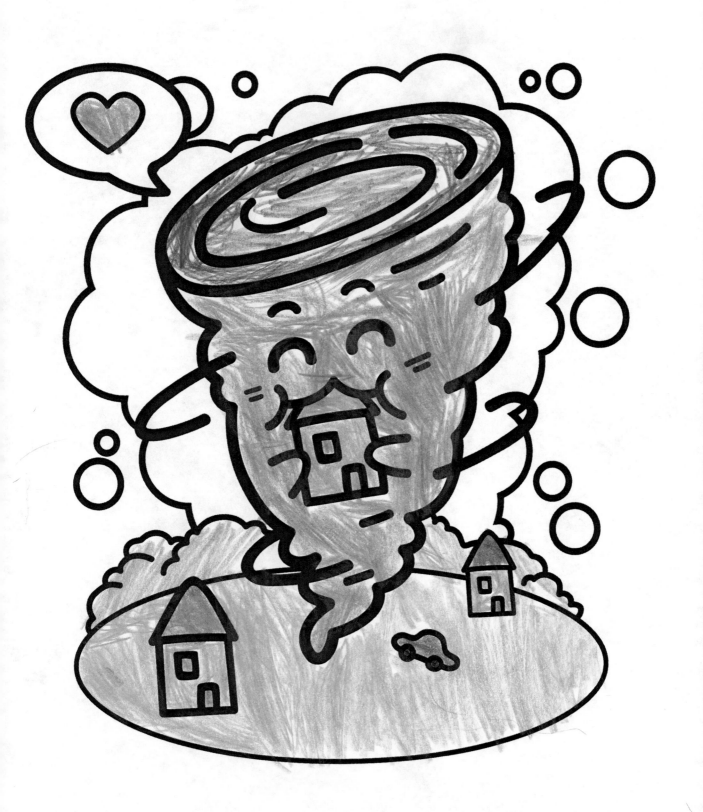

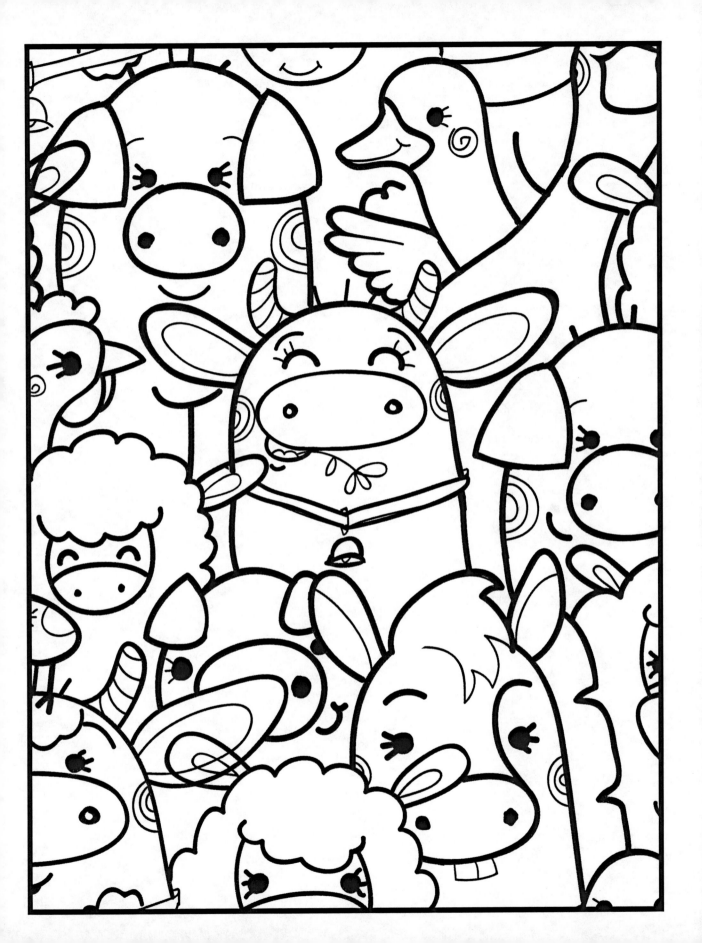

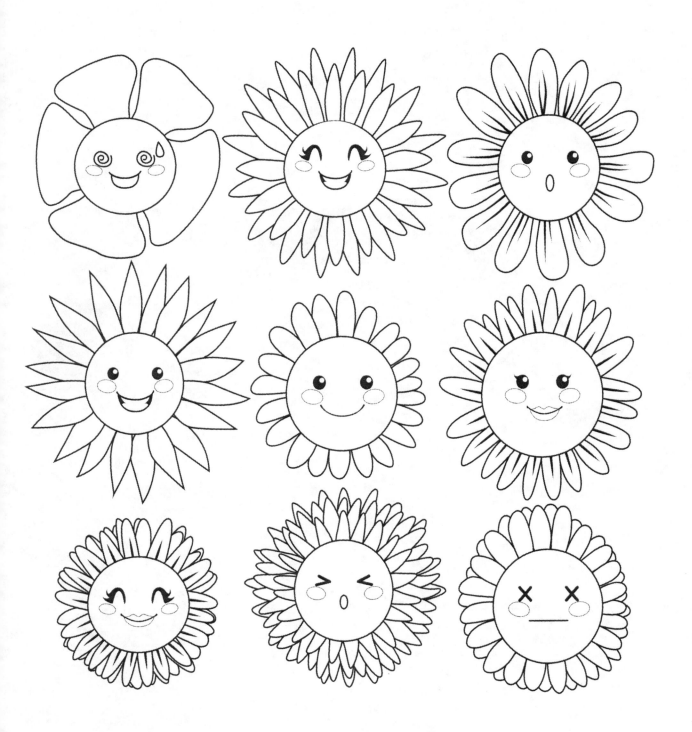

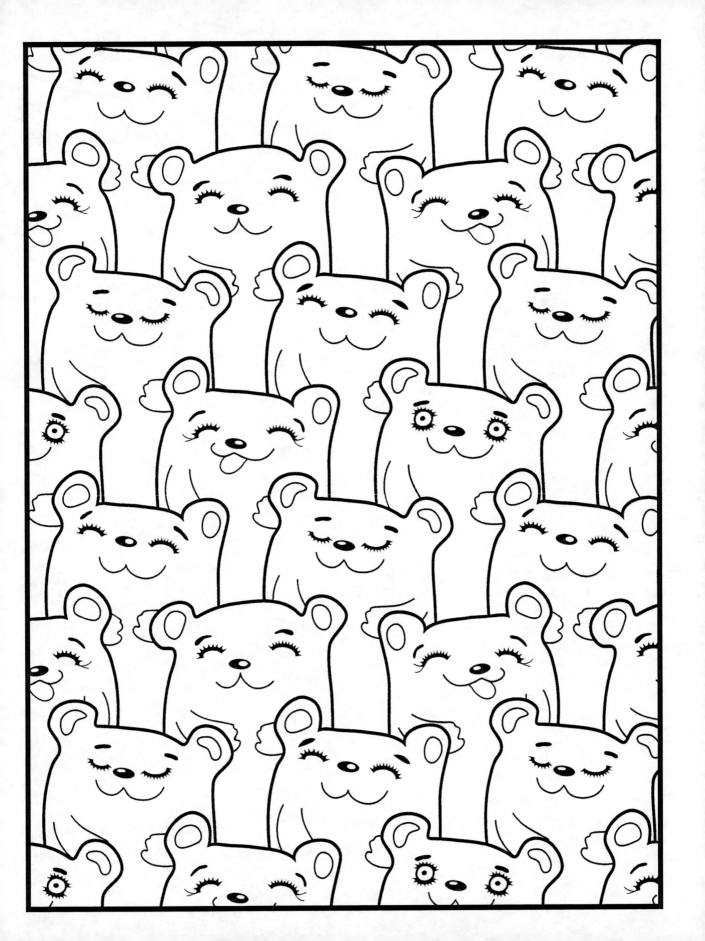

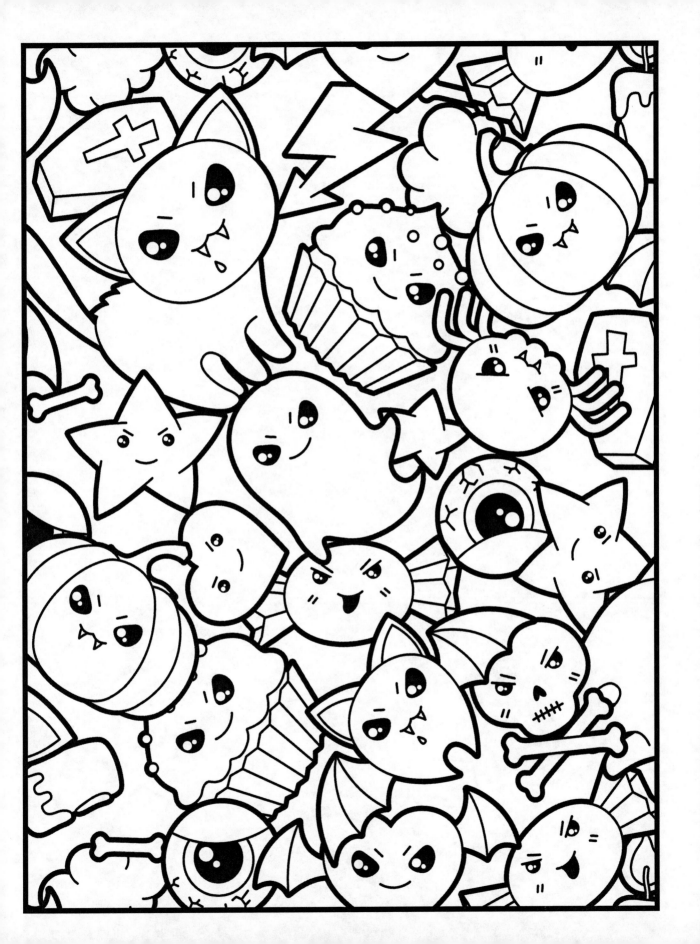

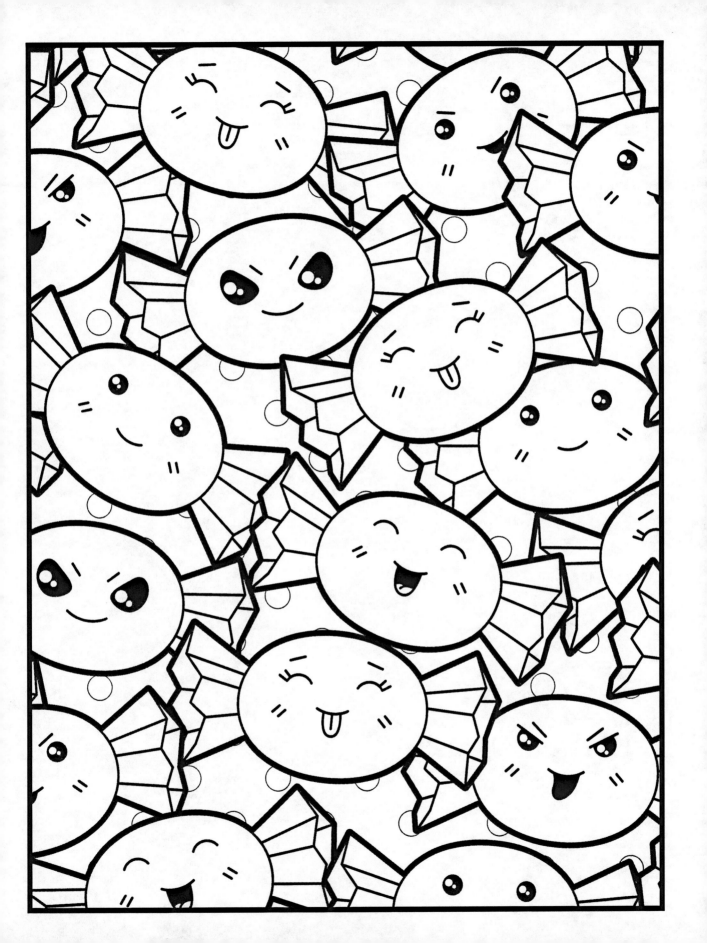

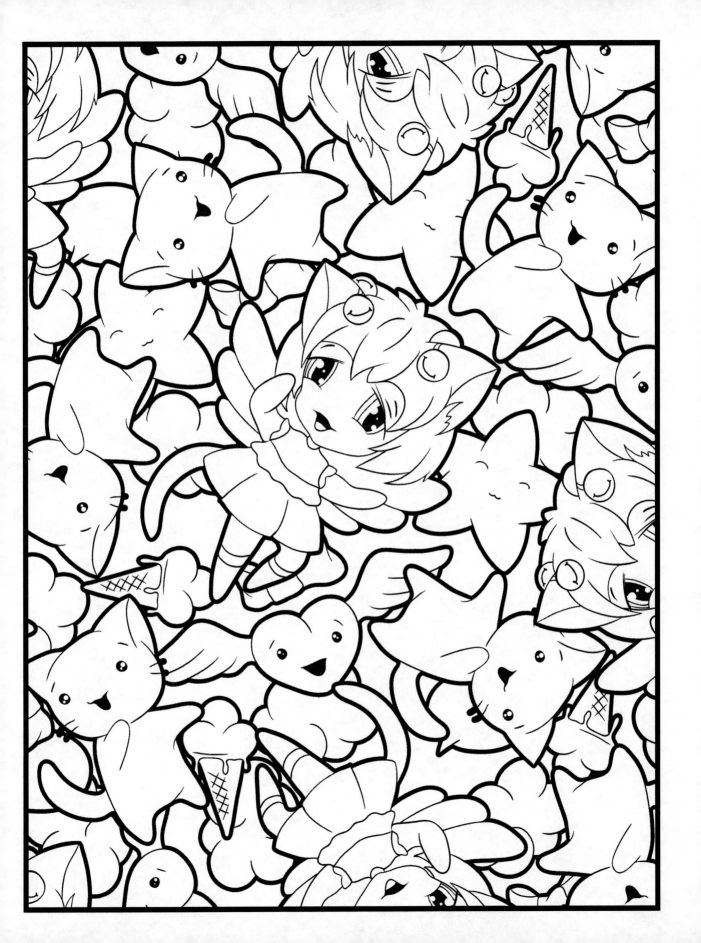

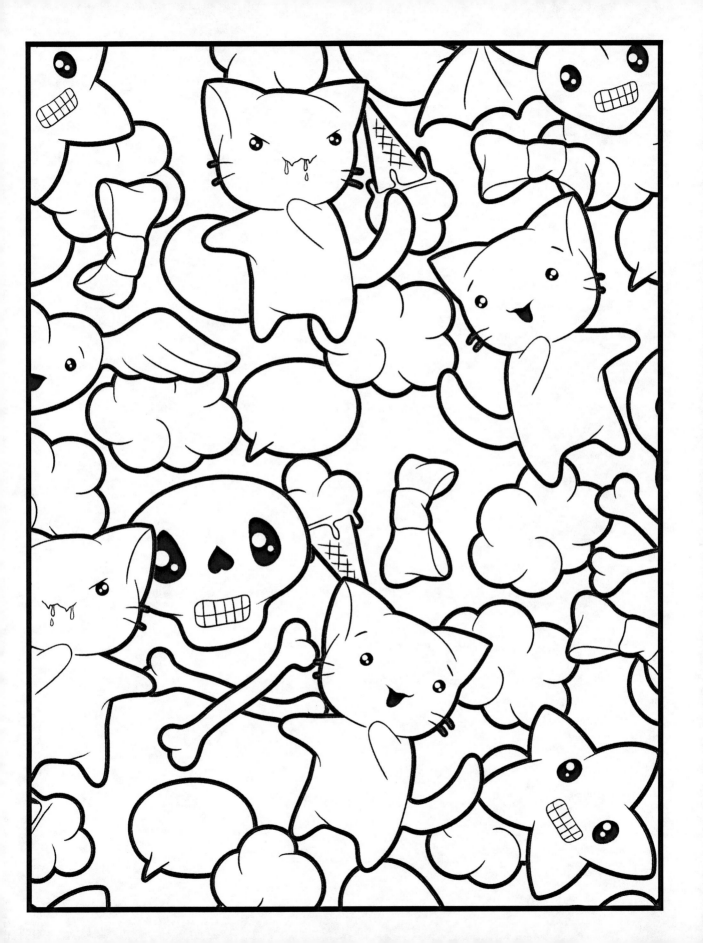

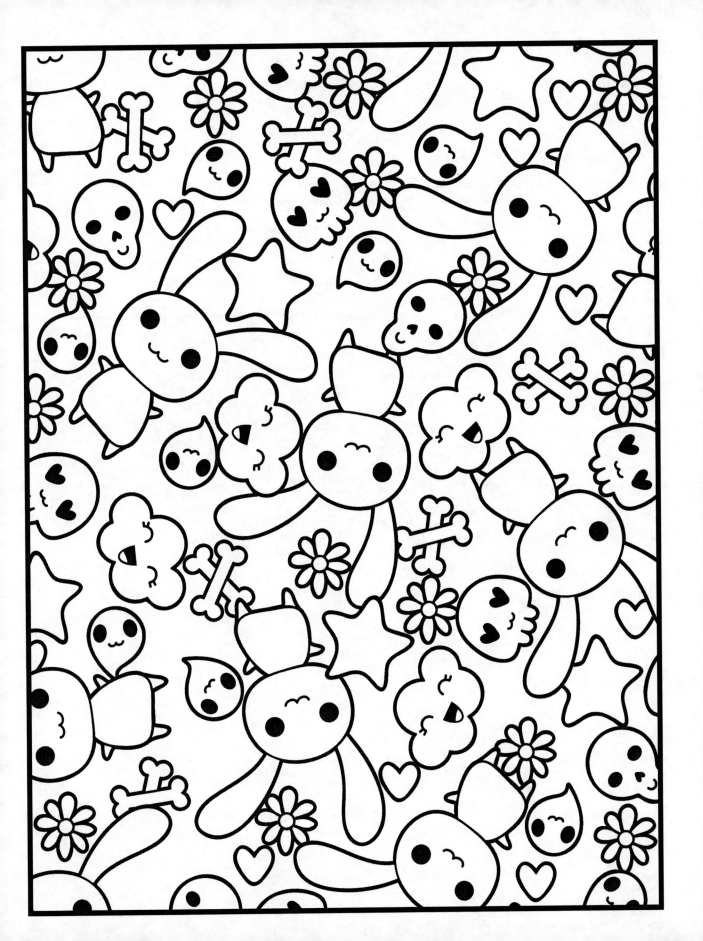

CPSIA information can be obtained
at www.ICGtesting.com
Printed in the USA
LVOW09s1150290518

578832LV00009B/418/P

9 781519 666413